IF I NEVER SPEAK AGAIN

SHARICE TAYLOR

authorHOUSE®

AuthorHouse™
1663 Liberty Drive
Bloomington, IN 47403
www.authorhouse.com
Phone: 1-800-839-8640

Cover Photo and Author Photo Credit to Sidney Conley

Published by AuthorHouse 05/27/2014

ISBN: 978-1-4969-1459-0 (sc)
ISBN: 978-1-4969-1458-3 (e)

Library of Congress Control Number: 2014909409

"This book is dedicated to strong women in my life; Channie Reed and Bobby Hamblin."

Thank You!

Contents

· · · · · · · · · · · · · ·

Introduction/Bio

· · · · · · · · · · · · · ·

God's humor always amazes me, and I say that a lot. I, Sharice can only speak for me, the shy one from the small, city called Canton, Mississippi. Don't get me wrong, I have always been the type to joke around, laugh endlessly and make everything funny, but I realize when things got serious I became quiet; I felt closed in and puzzled. I grew up not having much to say because I didn't know how to speak with comfort. I did what I knew best. Not realizing keeping my peace would turn and cause me to keep unwanted feelings such as confusion, anger and being misunderstood. I saw things I didn't agree with, I held back from speaking what I believe, and it made me angry more at myself than others. It took living life to realize I was scared to be free and afraid to take chances. All I could do was call on God. I knew I needed a way out, a hobby, something to do that would express who I am. This is a story we all can relate to. We become lost, but we have to define who we are, and where we fit, luckily poetry introduced itself to me.

I start reading and watching movies based on historical leaders, bold speakers, and activist. I no longer wanted to be shy, quiet, and fearful; I wanted my voice. I was struck with interest, pride and inspiration; I wanted to posses those characters. I didn't want just any voice. I would speak about my thoughts, my generations struggle, where we come from and how we can motivate each other to be successful. Words can unite us as one, build us up within to have the courage that will bring us together collectively. I felt like no one wanted to hear my problems or what I thought so I wrote it down, and I know most of us feel or have felt the same way. I'm not about grammar, and subject and verb agreements, but I am all about

expression and freedom. My ancestors were limited with their voice, but I refuse to be. Don't get me wrong, I'm not about disrespect, negativity and downing the next person I am about positivity, spiritual lifting and simply being real. So, if I never speak again you will know who I am with my words, how I feel with my words, and what I'm striving to become with my words... Enjoy!

Just Write

· · · · · · · · · · · · · · ·

From here on out,

I just want to write,

Until I can't write anymore.

My mind has been running,

And in order to stop it

I have to make my pen bleed from the pores.

With every moment,

Trying to make it to the mountain top.

I've been facing these

Battles, going through war,

I have come across a lot.

With the tears I've shed

The pain I had to sleep through,

The hurt in my mental.

Mama said there would be days like this,

Mama said it, and it is so true.

I can't blame no one but me,

Because of me I suffer this bad treatment.

Not carefully judging the book

By the introduction, overlooking the horror,

And now I have resentment,

Man, I should have paid attention...

Ms. Influential

.

There is a greatness I try to exceed highly,

Constantly on the flow,

Success must acknowledge me.

Ever since birth, mama knew I was special,

She called me by the best name,

Ms. Influential.

I didn't see it for myself,

Blue jean overalls, dingy tee,

A plain country girl

Is all I ever knew about me.

Quick to make a mistake, error

Clumsy in every move.

No matter what direction I walked,

As long as my butt was in school.

Coming up in a small, rural town,

Possibly, but easily seduced

By the negativity, pregnancy,

Drugs and pocket heat,

But those who reached out to me

Saw my potential.

They recognized me by the name my mama called me,

Ms. Influential.

Even though I heard them often,

I never took the word NO!

Nope, not ever.

Even had those type of friends,

Who also tried to knock me down,

Thoughts were brilliant, but actions weren't so clever.

I hope they didn't think they would ever,

Knock me on a floor that was beneath their level.

They must didn't know who I was,

And I am Ms. Influential.

Self motivated,

It was self who made it.

I took myself and bettered who He created.

The journey wasn't easy,

The pressure was hard,

And it almost overcame me,

But my Heavenly Father

Wouldn't let Satan put a claim on me.

So I continued walking,

While in the midst

Struggling, barely making it.

I am determined to be the best,

Of whom I'll ever be,

The name my mama called me,

Ms. Influential.

These Words

· · · · · · · · · · · · · ·

In so many ways

I've tried to express myself

Up to this current day.

From playing music, to dancing,

With slightly no sense of direction.

Of only at one moment I looked up to God

In need of a gift of relief.

Lord, I need something that will clear my path,

Brighten my light, Lord I'm asking

That you would speak to me!

And he revealed one word, by saying WORDS…

Speaking words is a form of relief,

Its in the way we speak.

They make the songs we sing,

The sermons we preach,

I have a lot of words in me.

But I ask, how can I make these words seem

Alive or even brand new?

The Lord spoke and said, "they are not new,

They're ancient since day one we've used.

As my Father was the first to say these words, "Let There Be Light!"

As Christ walked the earth and spoke the words.

My child, Rise, You Are Healed,

As Martin Luther King marched and said, Free at Last, Free at Last,

Thank God Almighty, We are Free at Last"

Even the words we use today are as the same as the

slaves used to reach that freedom peak.

See, words are more than words,

They've brought freedom for you and me.

These words are way more than a subject or a predicate,

Verb or an adverb, a noun or a pronoun...

They are the directions of life,

The blue prints of our mind,

The key to a locked door,

They are the death of many ancestors

Who have worked hard to even speak of them.

So you see these words are not me,

And like blood, these words must seep out of me,

There are many words in you

From "Lord I Thank You," to

"In Your Son Jesus Name I Pray... Amen."

These words have formed as equality for every

African American to be treated the same as every man.

And from this day forward,

I vow to speak these words with boldness,

With ambition and such intellect.

I promise to let these words stand tall, and bring changes,

Or better yet,

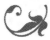

I'm going to love my words, and with God I am blessed,

And to these words I say let me introduce myself,

To these words I say I am so glad we met.

For words are in my life,

And to the world I will express,

These words...

A Message of Remembrance

.

It's amazing at how I think far,

Not knowing of the things that has crushed my heart.

Look at me, I am seeing stars

Of past souls,

The ones God chose,

Open life to close.

I realize that I know,

Face the streets both ways

Before you cross roads.

Never understand life,

But though we'll never know.

Here one day, next day gone.

Pause for a minute,

Within that sixty seconds,

A son, or a daughter,

A mom, or a father,

Could lease the benediction of a closed mark.

A grave site is no deeper of a clearer sight,

That we're not at all everlasting

From low class to high,

Example, from earth to heaven.

Live to the fullest is the real message.

Shedding tears for those who left me,

But the sweetest smiles on your face,

Is all I remember.

I guess a way of looking at it,

Is that our maker, is a lender.

To taste a snippet of living,

But to the skies we surrender.

To take advantage of the awake,

Is what we are all guilty of,

That is why we cry so hard,

Feeling the pain along with love.

Never forget the ones that leave,

For we will all meet again, trust and believe...

Peace

.

Peace be still,

Remain in me.

Plant that eternal seed

And let it be.

No harm shall face me,

Only the presence of thee

Shall protect me.

Casting my cares upon my maker,

My counselor, protector, my provider.

Bless me O' Lord!

I am your child, so from you I need.

Make calm my flesh,

Cause my spirit to become strong.

Keep me away from that urge,

Show me how to hold on.

You said in your word

That peace is not promised to the wicked,

So I speak with my tongue.

Lord have me, as you would want me to be,

Keep peace in me, your peace I need…

Amen.

Why? Be You!

· · · · · · · · · · · · · ·

Why is it that we

Only live accordingly?

Living in styles where others be,

Only do what is a fad,

Nothing brand new to me.

Walking behind one another,

Seen as shadows.

Born as individuals,

But now I'm like why though?

Historic repetition,

Updated vintage,

No single attitude,

Solitaire non-existing.

In fear of being what makes YOU.

No double-mint,

It really doesn't take two.

Be a representative,

For the one who created you.

Step up!

As one, a leader,

Make it personal,

No copycat.

No need in copying what that cat do.

Tell me, who do you remember

That was second and made it

From the first persons move?

Be you!

Receive, Exceed, Experience

.

Make hope for tomorrow,

Accomplish what we could not today.

Speak the unspoken,

Give to the less fortunate.

Love the unknown,

And care for the needy.

Let your flood gates open,

Receive and don't hesitate.

Exceed beyond limitations,

Walk, but don't run.

Step far from your comfort zone,

Experience how the sky is the limit.

Take in your many NOs,

But respond to that Yes, rapidly.

Lean to be somebody,

Stray away from the nobodies.

Be bold with your words,

And act on what you've been taught.

Hold on to God's unchanging hand,

You are that leader…

Take that stand.

No!

.

There is no way you can tell me NO,

Unless I break down and yell I give up,

But even then I'll man up and get up.

There's no way I'll tip over the cup God filled up.

Blessing after blessings he has blessed me enough,

The doors that have opened up for me,

I owe the most high too much.

And all he ever said was let go of a few things

And I will shower you with blessings

That you are more than welcome to receive.

So I began to cut loose,

And my heavenly father came through.

He's the reason why no one can tell me NO,

Unless I say this is too much and I can't go anymore,

But that is not my flow of direction,

Even when I am not expecting.

I intake so much because I know I'm ready,

No more standing steady.

I'm on a journey that's not even ready for me,

I can't stop, won't stop,

My success is endless for me.

Anything, anybody who tries to break or burden me,

That is a waste of time and that won't do a thing to me.

I'm too strong, I have a lot of faith in me,

He has brought me too far to have given up on me,

And all I can say is thanks, because he did it all for me.

Me, Me... Little ol' me,

I was the little girl with the big dreams.

I even went to college and got my degree,

But even in my heart I know God wasn't through with me.

So telling me NO is just like listening to birds chirp,

It has to be done, but it won't even hurt.

I am more than a conqueror and the struggles I had to battle,

It was nowhere near easy,

But with God on my side we mastered it.

I survived a lot, but mostly cried a lot,

And you know who I talked to.

That was one call that didn't drop...

So tell me NO,

Go ahead tell me NO,

To me NO is only short for NOT OVER!

No this journey is NOT OVER,

No my blessings are NOT OVER,

No my struggle is NOT OVER,

No my gift is NOT OVER,

And no my praises, my thankfulness, gratefulness are NOT OVER!!!

Gain Wisdom,
Lose Interest

.

Growing up, I always heard
If you really want to know or learn something,
Talk to the elderly because they have seen
And done it all.

And I questioned, what makes them feel
I don't already know?
They quickly responded by saying,
Girl you can't
Tell your pinky apart from your left
Or your right toe!

But it took the tragedies,
Trials and tribulations
In order to understand what they meant.
It brought me to the conclusion, that
I would gain wisdom, but lose interest.

As I am reaching my elderly peak,
I experience so many things
And situations,
I thought I wanted to be included or involved in.

But I only got resentment and regrets,

Wrong signs and technicalities

And the questions of myself,

And plenty of embarrassments,

But overall I…

Gained the wisdom, but lost the interest.

Running into the ones I thought cared about me,

And really had a thing for me,

The ones I held close,

And were very dear to me,

The ones I would take a bullet for

If it came closer to me.

With whom I shared secrets with,

Tight enough to call me Pocahontas and the other John Smith.

Slowly as I found out,

They were standing in their shadow of

Pain and hurt,

And they had to give back,

Didn't care who it was

As long as they shattered

The heart of another,

That could purposely kill them, but heal their womb.

That would soon continue to generate,

Like a hereditary bloodline effect

That would never stop.

Because we only learn

That love doesn't love back

And no ways to make it better.

Our pride won't let us back track,

And that is when we realize,

We gain our wisdom, but we lose our interest.

Having the dream and faith,

The size of a mustard seed

That she would reach,

The extreme of being

A bread maker, but never a bag lady.

And that lady falls for and has his baby,

And raises it, on her own,

As if she was the only one

Involved in the conceiving.

Trying to define life and its meaning.

Begins to let go of her purpose,

Just to barely raise

What she didn't do on purpose.

While in the meantime,

She gained her wisdom and lost her interest.

In who she once was,

And now she will not live to see...

Or that guy who always lived by the rules,

That law abiding citizen,

Who looked up to his father

And every move dad made,

He was apart of in every Godly,

Spiritual and physical way.

Daddy had high hopes for him,

Until he found out,

His son had a man that had love for him,

Father cried and pleaded

To give it up for him.

But son refused and said,

"Don't make me choose but only pray for me!"

Father gave in and lost the ambition

He had for his boy.

His future well planned

He was older guy,

So he didn't learn til later on,

While in the midst, that he had to,
Gain his wisdom, while he lost that interest.

There is something we don't gain,
Until we lose;
That person, that dream, that effort,
We put into.
To only go so hard,
But relive and only understand.
We are living life, but life doesn't live you.

Take back what it took from you,
Without knowing, we will engage
In a world,
That will show us,
What's for us.
We will hurt, have some hatred,
Face the hardship and wonder why
We couldn't dodge or let us miss;
That devastation,
That greeted me with a kiss.
While I gain my wisdom and lost the interest.

Honestly Stressed

.

As the night rose

Tears falling on my pillow,

So worried about life

Category of ordinary people,

Wishing I can see further

Futuristic peep hole,

Too hard on myself

And don't know how to let go.

I pray though, I ask God

To take the stress away,

I continue to think ahead

Causing strain in my chest,

Living less, no enjoyment

Being depressed.

The harder I strive the more success

Runs off and hide,

Not the best at everything

But in my heart I try,

And that ain't enough

To let a black girl slide.

In reality I am meant

To be denied, false advertise,

Of unity in diverse crowds,

Rejects I, like I'm born to be blind,

If you see me internally,

Then world, I'm sure I can change your mind,

Sweet and divine, courteous,

Well… sometimes.

But to be completely honest,

Willing to pray out anything that hunts us,

Us as in the world

Any boy or girl,

And what only hinders me,

Worrying about what's next for me.

Especially, wanting to know

When Sallie Mae

Will stop calling me.

My greatest wish is to pay off everything,

See I have great intentions,

But intentionally "they" don't want that for me,

Rather see my struggle

And call cardboard boxes home and feel snuggly,

But I say no way for me, continue to look up,

As I mountain climb adventurously,

Eager to find GREATNESS!

Shar-a-Phrase

.

We letting old stories control our glory,

Stop signs before happiness,

Wondering why great things never happen to us.

Memories become human beings,

Depression and inconvenience,

And confidence coverts to being timid.

Things happen for a reason

But no reason to create barriers,

That will only carry

Frustration and limitations.

Yes it could have been molestation,

Hereditary raping, drug in taking,

But God plants seeds for manifestation.

How a beautiful flower

Can grow from dirt and look amazing?

Praying for a new beginning,

Is the only thing that can change this,

Letting go and letting God

Is a healing statement.

New Avenue

.

There's a new avenue

I plan to take.

The heartache

That led to a headache,

That later made my back ache.

Made me realize

That some of my decisions

Just weren't good for me.

Everything that was a fantasy,

Tv-made, or read out of a book

Became more fiction and unreal to me.

On the path of living my life,

But every stone that was thrown

In the midst only distracted me.

And me thinking I could multi-task,

Only created a deeper hole that was too deep

And I lost control.

Pretty much down to the last breath

Of trying to hold on,

No friend, no associate, not even a mate to call on.

They claim to have existed,

But no one I could depend on,

I knew right then

That there is a new avenue... for me.

Somewhere I never been.

Every time I pick myself up and dust off,

A different temptation would come

And my sinful body would fall into.

When all along my mind would say,

"Girl look at you"

Constantly facing the hurt

That has broke me down,

And even messed with my mental.

The thoughts of depression and suicide,

The decisions I made,

Almost made me give my life to,

The devil himself,

Who would've been proud

To make my life finish and through

But that's not how it ends.

That's why I'm searching for a new avenue,

Broken promises, love affairs,

Back biting, having those in my life

Who didn't even care.

Who saw through my hard times

With my last dime,

And tried to take everything that was mine

Me and decisions were running out of time,

Basically by myself,

When everyone who was standing around,

Pretending, they were just lying.

Being at the end of my roads,

Solitaire Boulevard.

Hanging on by myself street,

That broke me down

But no one did it,

But my decisions and me.

So no one to be mad at,

But my decisions and me.

Now I must accept a change,

My decisions and me.

Something has to change:

My thoughts, my approach, my maturity,

To breakthrough and continue

With my residual.

To start all over at the beginning

Of a new avenue.

Starvation in Strive

.

I'm that homeless woman

Standing on the side of the street,

With that sign that says,

"feed me, I am hungry"

The opportunity is out here,

Go out and grab it,

I'm starving, I am a go getter,

Its just a matter of time before it all starts happening.

No more sitting at home,

With all the wishing and praying.

They say faith without work is a waste of time is all I'm saying.

Nobody is going to knock on door

And say, "hey, I need your gift, bring me your talent!"

I want somebody to see my work and admire it,

And know that I am magnificent!

I'm beginning to take a step out on that path,

But in the mean time,

I'm running because I know there is something out there for me.

#TEAM

.

God did you take all the time you needed to create me?

Or was it too much time and I was suppose to be born

In '38 not 88?

Or even '63?

Having that old soul,

Never cared to be everyday jazzy,

But when I did,

They be like snazzy! Vintage right???

I just said I guess, and thank you to be polite.

#teamNICE

I even questioned, was I suppose to be on #teamEARTH?

Or #teamNOEARTH

You know, #teamMARTIAN

Or a soul from the past

#teamREINCARNATED.

Some Egyptian queen,

Or Harlem homeless wo-man.

I really don't know!!!

I even felt like an un-equivalent chemical mix,

More electrons than unfound protons.

Or a silly stir,

Like a dark soda with cranberry juice on top,

#teamDON'TMIX

All my so called friends were darker than me,

Thicker than me.

Hair longer than mines,

And I was smarter than them.

I was that one pointy needle,

Somewhere lost in that bundle of hay.

A group walks by, keeps going

Ignores me when I uttered "HEY"

Boy, did I feel like #teamDUMBASS,

But then again, I'm like AYYYY!

If I found my way in a crowd,

Then who would notice me?

Not even with red and white stripes,

#teamWALDO.

Could you rectify my weirdness, uniqueness,

My spontaneous search

For words that can identify my mental,

And dream search or indulge in me,

Training myself to look in the mirror,

Embrace I and love oneself,

Even when no one else could.

I'm just meant to be #teamMISUNDERSTOOD

To the world.

As long as I understand,

That solitude made me a great wo-man

#teamYESICAN

An individual who has always had a visual

And always focused on success

#teamHUSTLE, strong #teamMUSCLE.

Yes I became mature,

Put down the clicks and #teamUS.

So I post a picture on instagram,

One of myself,

And beneath I put,

#teamLOVE, #teamME, #teamBLESSED, #teamSHARICE

We are Not Bitches

.

There is a time to speak,

A time to be me.

This is the time to be poetically free,

I'm not so much of the world as I use to be.

There are plenty I oppose of

That will forever be explained correctly,

Forever unclear to me.

I don't want to call the next lady a bitch,

Incorrect title of a black queen.

Don't want Mrs., Ms, or beautiful to be unfamiliar,

Can't bleed, let it lead,

To the next generation of daughters.

And tell them it's okay for them.

Or even take it from a man,

It sounds better from them.

To tell a rapper put it with music,

Degrade her, inform the world.

There's more than one created,

And all the way to their souls.

Make them feel hated,

Go ahead and call every female

That was Godly created that BITCH!

And as to every female species,

I'm speaking of your mother, daughter,

Sister, cousin, including your aunt.

The feeling is not so pleasant!

Well, consider the mind that intake.

To where her heart be like,

"Oh' that's just an expression.

That's what all humans say,

Its just what we feel like."

To put down each other,

This is the outcome of our ancestors dream?

The struggle and killings of the freedom riders.

I assume this is why,

I am freely writing.

Don't want the misled to guide us,

Into misleading each other.

No human grows and dilutes to a dog,

With a chain around the neck,

Eating mouth first and downward

As saliva forms and leaks out.

Your mother is not covered in fur sleeping outside in the back,

Protecting you from an intruder.

Your daughter is not only seeing black and white,

Raised to be diabolical,

And fight until their heart stops

Or even catch balls in the mouth.

To only fetch, whistle and bring it back.

Little Jimmy grows up,

Think it's cool to yell BITCH.

Is that the name mommy was called to?

The same name her boo called her too?

Your father,

When he was drunk and heartless.

Now you call it, like second nature and thoughtless,

And in her mind it still bothers.

You were not born a Bitch,

You are not raising a Bitch,

Your sibling is not a Bitch,

You are not a Bitch,

And I am not that BITCH!

HATE

.

The USA, land of the free,

Only to a certain extent and a low degree,

How free could it be,

We living in a land where hatred breathes.

So hard, we catch a cold while it spreads with a sneeze.

The same hate as Cain and Abel,

Centuries ago!

But we still do it like its new

And we watching it like cable.

It increased back into slavery,

We were hated for being darker than a disliked memory,

Taken advantage of, tormented physically.

The hate in us, is the hate from them.

When they learned what knowledge and pride was,

And my people, they tried to take it all from them.

Hated for being a color,

Black, white and many others.

Decade after decade,

Hate grows like fire in rage,

And as people we're converted into dvds and just letting it play.

How can you hate my brother

For passing where you stay?

With a hoodie, bag of skittles and tea a normal day.

Didn't like his color,

So you showed foolery and laid down that brother,

Rest in peace my brother.

And how can we be against each other?

And say, "I don't like her!"

"But why?"

"Because I just don't like her!"

Now we were born with no sense,

But lets not die with ignorance.

To me, I think that hate was formed to be a test,

To learn its form, while it becomes less.

Less of a feeling, less of an action,

Less of a criminal womb,

But most of all less mess.

God is Love and we ask God to show in us,

But hate is the devil so there is no room.

Not even to discuss a heartful status or bible verse,

But quick to cuss and curse,

A soul we don't care to exist anymore.

Man, I'm living in a land

Where we don't welcome God anymore.

Hate is a sin,

Something that should have never started,

But in unity we can bring hate to an end.

My Small City

· · · · · · · · · · · · · ·

It's a well known fact; they don't want to see me make it,

Stuck in such traditional ways,

Describing me as a regular employee,

Say I came from little raised in a small city,

They say I will never know the feeling of having many,

Poor little girl from a setting, could I ever change?

They say I'm from an area, where kids having kids,

Barely making it, no type of benefits, say we're

stuck in a mind where guys sag and show

drawers and call it hood rich.

Giving up on the young while they care less about education,

The only courses that gives interest is when

they take gym or talk about sex,

But only then its all about pulling out and latex,

They say my small city is gang related and every

hood for themselves its all about getting

Money and nothing else,

So corrupt by television, but in my mind I have a

vision that all of this ever spoken can be

Flipped and changed easily,

Does anybody else other than me have that belief?

So many are born here, grow up here, obtain the

knowledge, leave and never come back here,

So how can we expand when our populations
of visionaries are no longer here?
But every crook remains who else can your son look up to?
In my small city it could be a fairytale or a trip to Disney,
But it is a place for growth and development,
Where small brains extend beyond articulate, who knows???
My city can be holding our next president!
And if we start by changing the little things
that for me is enough evidence,
But they say I can't make it from this small city,
Why they can't expose our realness?
Where I call home every movie that was made,
They open this display from way back in the days,
Every street makes this city so why hide or be ashamed?
I would never want to portray this image that
proves we are remaining in the living of
Wild horses, white owners, and black slaves,
The separation of mankind that is not how we live today!
Maybe mentally but not by action,
If you want to make a difference then we can make change,
Just like the description of a dollar, equals 4 quarters,
10 dimes, 20 nickels and100 pennies,
But the exact change,

That can be resemble us being who we are but enlarge

our ways so that our path can become

Land where grace and mercy has touched down

from a miracle that forms unity, in my city

Where they doubt I can make it,

In my small city where there is error now is the time to change it!

A message to my people from my city...

What's Your Purpose?

.

Discussed an issue on hate,

Feelings from person to person,

So I stand clear to say

I hate the actions

We're putting forth today!

Today we do with only what pays,

And demand increase,

Strutting with crease in pants,

Crisp tie, sharp horns

Devil in blue dress,

Using their purpose

With open pockets.

Smile, with a mind to destroy,

Create mess,

Confuse mind to say "I'm Blessed"

But really a hoax,

With the same goal of Lucipher.

Won't leave until its finished,

But hands out, like where's my paycheck?

That's a teacher with a threat…

No turns for progress,

Kids learning less, being ignorant.

Saying "Duh", with dumbness.

So you don't think that its wrong,

For an instructor to say,

"If you don't get it, then you won't get it today?"

That's a diploma on delay.

Now that is a mind that doesn't care.

Teacher say, "I DID IT, BUT YOU CAN'T!"

"I'M THE ONE GETTING THE MONEY, YOU AIN'T!"

Better believe he drops out,

To prove, and get his money up.

But didn't know that hustle

Would take over and kill him.

No one cares,

No one with an honest heart

Is really trying to be here.

If it's not theirs or their own,

A reaction of a blondie, walks off

And flips hair.

I don't trust my

Not present son or daughter

In the hands of a man or woman,

That will not create

Or open those doors for them.

Yes! It starts at home,

But I want my unborn to learn more

than the front door.

And that's everything else beyond the wooden porch.

Call me crazy,

But I'm already praying

For the trust of the hands

That my child's life is in.

I want the same guaranteed opportunity,

Learning ability, books, effort,

And commitment.

Scholarship, loan, grant

Overall equality,

Most importantly that push that Obama had.

Yes I want the best for whom I have,

That future man or woman.

Yes we have Black History

But what changes are we currently making?

To say we are promised a FUTURE

Of no repetition of where our history began.

I hate we don't care anymore,

If we have a purpose

And never got paid for it,

Would it kill us

To prevent hurting the generation after us?

What is your purpose

That was given to help others?

My Purpose

.

Grabbing my pen and paper

Only lets me know I have purpose in my motion,

Even if the words become senseless,

To jot down what triggers my brain was well needed,

I apply with effort, but effortlessly make a point

That wasn't intended to be.

You must understand that with every message,

I write carefully,

Because where I am I prayed to be.

Truth be told I never saw myself living beyond the age of eighteen.

I couldn't see what was in me to offer the world,

So you could imagine the plea in my prayer begging God to use me.

I knew ultimately without him there is no me,

I can only feel the dead end.

No more road, darkness, lost with no looking up or no going forward.

Maybe I'm tricked in my mind and I may have given

The devil victory but I see death there is no long term for me.

I am the true definition of filthy rags I have nothing to give

That can be planted and proceed with growth.

God this is me who speaks I am no fortune teller,

But I learned over the years that you are the beginning,

A miraculous healer who knows and sees all,

Who tells us, so Lord tell me and show me that the message

I provided is wrong…

I write for my life,

Without words I do not have one.

I grab my pen, a tool that tightens my weak errors,

And builds my knowledge.

I have a rhythm that moves from struggle to my joy

Because there's once was but now there is.

There is a reason I write, I speak,

I have a purpose that was purposely given to me,

I am purposely a poet, poetry is my life!

I Shed A Tear

.

I never realized how my emotions had a hold on me.

The feeling of a strong hand, squeezing my

intestines barely breathing until I let go.

Finally I let my heart bleed.

Shedding the tears for the many things I've held back for years.

I shed a tear for that child that has felt neglected since her early years,

When father was no longer around so she carry the fears of attachment

With anyone even with peers.

I shed a tear for that someone who has heard every lie,

Broken promises that only motivated her to keep going but realizes later,

That at the end those words were spoken for

intimidation and said to break her.

I shed a tear for the one who watched her mother work until the last,

Just so her daughters could have, which made

her mad and swore to work hard

Because she refuse to struggle as she sees the scuffling of her mother

But only for her, because she loves her.

Of which the many things we fail to realize, but should appreciate.

I shed a tear for that young lady who first saw her potential role models

That she looked up to.

He was that teacher, preacher, that deacon,

or some motivational speaker.

That couldn't wait until she graduated high school,

So they could admit how sexually attracted they are to her and admire

Those child bearing hips.

That's when her heart skips because she's lost for

words and her mind is on a confusing twist.

I even shed a tear for that grandchild who is soulfully connected

To someone living as a passionate provider, and called grandmother.

Strong, but when child was young,

That grandmother was almost gone when heart failure almost won.

Pleading, "Father I need her, she's the fist of our

family, my best friend, the wisest."

And God kept her around, the things God do to surprise us.

But if that was a lost, there would be a lost child surrounding us.

I shed a tear for the many conflicts of numerous characters,

But all tied into one.

I shed a tear for a few experiences that are eternally stuck in my mind

But recently realizes that it has affected me.

And the only thing that cleanses me are the tears that pour from me.

And it all connects periodically...

I shed a tear for the separation, devastation, neglect,

But the perfection of deeply cut wombs.

And I'd whether shed my tears now

So my lifestyle can be healed soon.

I shed a tear so my pain can no longer live on.

Who Am I?

.

Hard to recognize, when wondering who am I?

First name, Sherry

I go by Sharice, but my last name…

Who originally created that for me?

As I reflect back into slavery,

My family were owned by other families,

Who built a foundation,

And mines worked on every occasion.

Rain, sleet and snow

They picked and pulled,

And own food, they had to grow.

We were controlled by every step

And their name was an add-on,

Hatefully adapting to what had to grow-on,

As if we were adhesive enough to form a bond.

It was nothing we agreed on!

They never claimed my ancestors

As niece or nephew, a brother nor sister,

More like Aye you! Or my Nigger!

So they figured,

To carry the name they started and build,

Let it generate, as we populate.

Not trying to form hate,

But I can assume that idea left smiles on faces.

Basically, letting our African descendents be replaced,

And the more years came, it would be hard to trace.

Who am I?

My ancestors were born from what village?

Were called what tribe?

I was born by the greatest people but who and where?

Hard to recognize, when wondering who am I?

First name Sherry, I go by Sharice,

But my last name,

Who originally created that for me?

Shar-A-Phase #2

.

Can't say I had the hardest struggle

Or living was too rough for me,

But I have these thoughts

Of what if I don't make it to live my dream.

If I was too nervous to live my purpose

And death took me,

And that's my cursing.

Left me hopeless,

Like what was I made for,

No bravery, to speak

And that was what it was made for.

As I continue to pray on the thought,

Continuously working jobs

That only get me through.

Not saying that I'm not grateful,

But God blessed me with something to do,

And if I don't use it

Then he can take my talent

And then me too.

So to ask why,

Why can't I be that vessel?

Time would only tell

On what else I am created for,

But I'm not created to not do

Or be bored and left to rot.

With no plot and no story to tell.

To live that way...

That is a NO NO!

911 CALL!

.

Attention, Attention!

This is my 911 call,

Not because I need it,

But I know for someone

I have to speak it!

This beautiful girl,

Who did not know who she was

Or that she is,

That lovely somebody.

Whose body,

Was created by this miraculous image

Of yet we have not seen.

But though every late night,

Among every hour

She cries out the pain

Of her childhood,

That was never good

And it reflects in action.

When man are on a contestant routine

In and out... just passing.

Passing her around
While in confidence.
Continue to go down
And this train their pulling
Is not the first time,
But they are energized
To go a few rounds, like boxing...
Muhammad Ali style.

When done she faces the mirror,
And not clear of who she sees,
But what she does see
Is the complete failure of
The princess her father
Imagined her to be.
O yea, the first and same man
That made her drop to her knees.

The beginning of her depression streak,
And all she can think
Is, if only I had a little light in my life,
Or an exit I could possible reach,
That ounce of happiness
Would mean the world to me,
But only in her mind she keeps.

Now everyday, constantly
Everyday that pain bleeds.
Everyday she's weak
And tired of it all
And begins to lose her belief.

One day, she had a thought
That said, now this world needs no more me.
I am worn, have laid on my back long enough,
And refuse to live and see another day of darkness.
This girl I am unaware of,
And with her thoughts I am afraid of.

If only I could have been there,
To let her know that somebody is here.
To let her know you are beautiful,
And to not let anyone tell you different.
If only I had been there
To hear her stories,
To share her pain,
To let her know that God is here
And his relationship with you will never change.

If only I had been her
Sister, cousin, mother or friend,
Either one she could have called
To admit she was at her end.
And I could have interrupted
And busted in and grabbed the gun
Just in time... BUT...
I wasn't this or that,
Or didn't make it in time, or at all.

To let her know she is beautiful,
An angel, a special someone.
And little do we know
That this is someone,
We may not know
Or as simple as someone right next door.
This really happened after all,
Because we did not show that,
Attention, Attention
That 911 Call...

Be that!

.

Excuse me,

I'm not here to take up so much of your time.

I have to make this announcement.

When I was created,

I wasn't fit to be a judge

Not the one with the gable but the one who oppose,

Of an appearance, someone's ways

Or the way we love.

Quick to put our neighbors down

Like we're suppose to be unbalanced.

As one remains low and others above.

But in his eyes we are all the same.

We are in church,

Yelling out Jesus name

But can't call a fellow brother

When he's dying or in pain.

See the same sex holding hands,

We turn our nose up

Like I don't support that,

Call them ignorant, hell jinks,

Build a little hate

And pray that God keeps up straight.

With the ignorance of judging,

More youth are picked on

For being who they are,

Or family in a struggle.

Anger escalades so he meets bully,

With a gun in his hand

The peace (piece) speaks.

No one is laughing,

Old bully meets new, (young reaper)

Certain words are keepers.

No I'm not rocking

Versace, Gucci or Louis.

Never request to be upscale living for name brands.

Striving to make my name well branded,

Upscale and remembered,

Universal, I am heard from dirt up.

On a journey to speak not only when spoken to,

I faced God and accepted the duty as his vessel.

So I will only speak truth…

Can I live?

I mean really as I am?

Can I be the bomb? That psycho?

Maniac, mental brain-iac,

Whatever you accuse me of,

I'll be that...
Let me be that dependable somebody,
Christian, business woman,
The stranger you've shaken hands with,
And never saw again...
That strawny kid, the bully picked on,
The smart sarcastic jackass
Or simple, pretty lesbian
Or candy lady with four kids,
And three baby daddies ,
Guess what? I'll be that!

But I don't need your words,
Thoughts and your biblical interpretations sizing me.
Telling me who or what I should be,
Basic Information:
Let every soul live in happiness and peace,
Let every soul live for ourselves as individuals.
Whatever you accuse me of,
It don't matter I'll be that!
It was never a humans job to create me
And a human was never hired to break me...
I am only what I answer to
And to what I am...
I'll be that!

This Is Us

.

Created to be the head,

Not the tail.

To not be judged,

But wish me well.

Mentality of a profession,

In taking these lessons.

Steps into the real world

No chance at winning.

To say I'm over qualified

And need experience.

Over looks our intellect

To confirm our gender and ethnicity.

There are some wrongs in authority

This world holds too many Indians

And not enough chiefs.

No more helping the next man,

But to have the enjoyment

Of not seeing the next man make it,

Another form of hatred.

All I can say is wish me well,

And I also so "You Know"

Because you know as well,

There is no equality

In the U.S. of Hell...

Strong Black Woman

.

To be or not to be,

That strong black woman?

Is a question I ask myself on a daily.

That type of woman I've came across

In my home, my church,

In a book,

Somewhere down in history.

That strong black woman who prays faithfully,

For the covering of Jesus blood on herself,

As well as her family.

That strong black woman,

Who shares her belief, takes a stand for freedom,

And will fight to the bone

With the grit of her teeth,

Just to prove her point exactly.

That particular, strong black woman

Who would give her last,

Just so her daughters would have

And even at her saddest moments,

Would still keep your spirit high,

And enjoyable with a laugh.

Indeed I am, and that I planned to be,

That strong black woman,

My mother raised me to be.

Things To Do

.

I am being subjected as a witness

For which I don't want to take a stand for.

The many deaths that have been taken place,

To put end to racism,

Hate crimes have been in vain.

Every lane, we've thought to be set straight, are crooked,

And every congested and complicating

Reason or statement has not yet to be made plane.

The conspicuous odium that tears us apart as individuals,

Instead of building us in unity,

Where as we all should come together

Under one body, one man, one God,

That surpasses peace and serenity that we find so hard to reach.

For only as this land is temporary,

Its only right that we experience a little paradise on this earth.

Instead of feeling the effort and hard work of our ancestors

Come from being a blessing but converted into a curse.

I am famish to see the illness of the mentality

That one skin color is better than the other,

Or one gender over powers and the other be destroyed,

Deleted and become extinct to which our memories cannot recap.

This world has become so dysfunctional,

That seeing equality and justice is a fairytale,

Written in a book that is not completed nor published.

This is a reality check:

Mic check one, two

Are you listening?

Is this message getting through to you?

This is what I speak of continuously,

Until I see vividly there is no more racism,

Judging of which has never been in our description as humans.

To only borrow the land,

We walk in disobedience and less innocence,

And its hurtful when we die young,

Even in our youngest years.

Emit Till was even innocent,

And in the millennium these tragic deaths is what we still living in.

Yes I will tell it, speak it to the next generation,

So all of us will remember and never forget it.

Not to speak against, to turn from another,

But we can't cover and let history be hidden,

Forbid to hide behind sheets

And if you ever heard of that,

Then you know the struggle of our ancestors.

From Dream to Nightmare

.

In a predicament,

Not knowing if I came or went,

Frustration on my mind

Expressed with anger on my face,

I swear I'm in a place,

Where I feel like breaking down,

Might even grab a pipe now,

That's just dumb talk.

Grabbing your attention,

Letting you know I'm dead serious,

Since I'm going through,

I haven't looked in a mirror since.

Can't face the struggle that I'm carrying,

So this upside smile,

Means I haven't smiled in a while.

The tense in my neck,

Means that I'm worrying,

People yelling go for your dream,

But not really getting it.

To have a testimony,

There are crippled moments that we have within.

I guess this is the part that I am experiencing,

God I need your strength.

Can't count the days, I wanted to give up,

Still counting the nights I've yelled

I don't give a you know what!

But how my life would feel ending,

I'm not climbing up.

Stepping stones of useless jobs,

Only used them to work on my people skills,

Since they say I don't talk enough.

But though I write enough,

Second King James, but unbiblical.

Expressing the moments of grabbing the short hand,

The un-equivalent opportunistic

That fed me thoughts of never winning.

I just blast my headphones with music hints,

Thing of a master plan,

Born sinner, but still a winner.

In continuation, staying agitated,

Quickly to explode 9/11,

Prefer not to discuss,

Call back later between the hours of 9 and 11.

The way this hell-filled works,

I must strive to get a piece of his heaven.

And since I know I'm dying someday,

I'm willing to take all chances.

Standing in front of the world,

Mohawk and all,

Thoughts and eyes have seen,

Confident to tell all.

Me, the young black woman,

I am asking society, the government, the judicial system.

Why make it so hard for and another to be something?

As if I owe the world something...

Please know I am not asking for anything,

These are the words from a woman

Who once had little girl dreams.

Survive

.

Everyone just wants the change to make it.

Don't judge a life, you were not the one to create it,

Struggle and puzzled actions,

Every human have errors.

Being broke, unstabled,

Confusion, we deal with the horror,

All the bad coming towards us,

And when we are at our highest,

No one is there to applaud us.

God is for all of us,

But even when discouraged,

We say this is all to hard for us.

Nights are forever,

Shedding tears that doesn't end, not ever,

Just settle for hope to have better.

Applying what knowledge fed us,

Economy dreads us.

Worrying at late hours,

Do I have enough to feed my family breakfast?

This world just wants to break us!

Our story is untold,

Not many of us speaking,

Trying to fool the eyes that see with gold, silver and pride,

A style worth chasing? Hunger worth facing?

We don't want to live and die as a lie,

Trouble in my way I can't deny.

I attempt to want to follow and let go of the unrighteous,

But the long term aftermath,

Consequences to suffer for acceptance of devilish,

Which is plenty of what we do not need.

But in the end we don't speak,

Nor do we teach how to survive in a case of unity,

But we survive for ourselves a world with no siblings.

To the most high protect us,

Because we know no better than our previous lives,

We must define our trust that will bring us out.

Our sight is blurry, but we all have read how you help the blind man see,

Now a visionary, because his faith was already there.

So to our most high, help us not to lose the trust,

The size of a mustard seed.

The storm too shall pass,

for we are only in the of the sound of rumble and roar,

only to end in sunny days and cool breeze.

And I humble myself to say when this storm is over,

I will be different.

Left with memories that will allow me to see that I may not be

What I should be,

But at least I am far from what I use to be... Survive.

As I Rise

· · · · · · · · · · · · · ·

Can't be too inspirational,

When my soul is full of sadness and hatred,

But constantly trying to protect like latex.

Hustling any way I can to take my mind off of it.

Trying to move where I'm from,

Where there is no more happiness.

My significant other asked me what's wrong?

I just said, "I'm tired of this!"

I'm putting forth so much effort,

But no response to my moves no matter how I shift.

I even had the thoughts if death could replace my misery,

But then I think I'm too pretty for such weakening actions.

I'm not giving up!

The thoughts of a middle class adult,

When the child is no more of me,

These jobs are destroying me, bills killing me.

I know for a fact that this life is not made for me.

They say I'm too young,

No kids, you should up and leave,

But why I'm still here?

I am trying to see what is caging me.

I'm so bottled up,

I know there's a message.

I just want to see,

If you throw it in the sea

Who would find and have a response for me.

And before you ask, I have talked to God,

That is something heavily instilled in me.

I just want to understand,

What it is that's made for me.

This southern caged bird,

I'm just waiting to sing something glorious,

So rewarding.

I'm working pretty hard,

But the outcome ain't too sweet.

It has a bitter taste,

The kind that makes your eyes squint.

I have a few errors suffering with anger,

Taking it out on others.

Lets just say my tiny circle,

Is getting smaller and smaller,

Not many to talk to,

Very few to call up.

So I accept I have to face this alone.

So if it converts into insanity,

No one will notice,

Its complete normality, when it comes to me.

This fire and desire I have,

I swear my heart is burning.

Lord that moment, that light that I ask for,

Grant it for me, ease the hurt,

Before it all ends for me.

Questions

· · · · · · · · · · · · · · · ·

Getting all these questions,

Twenty one questions, 50 cent.

The change in my pocket,

didn't know I owe explanations, irrelevant.

Asking me, what is it that you want to do?

You have a diploma, and a degree,

And its nothing regular, its in biology.

Will you use it?

Or let it be?

(as if I didn't know)

Asking me, will you teach?

Perform surgery? Or go for your Ph.D?

I just look them in the eyes and said, "I just want opportunities!"

Honestly, 9 to 5 is not meant for me,

Controlled by employers, updated slavery.

I am a new beginning,

So when I make it to the end,

I tell God "I lived while I was living"

I'm tired of repetition, and not to mention,

Letting some things happen,

That I just don't agree with.

And silence is no longer an option for me,

I've quiet for years,

And that dead end has gotten me anywhere.

Coming from a small town, it don't matter,

I came from something, so that means I'm going somewhere,

And to down me Oh well,

If I don't make it, and I fall,

I still won't fail.

I just know there is another road, and I'll detour another trail.

Are you poet? Writer? A lyricist now?

What is your title, will this be your way out?

I just say you're a bit off,

I'm free, I'm me,

And my hard work will pay off!

I'm a leader, a listener, a believer, an over achiever,

A free at last bird,

Once they opened the cage up.

A southern bell, what the world is in need of.

Even a revolutionist,

Help make a complete turn something we dream of.

What better way could I have answered your questions?

If I'm a topic, than I am a complete subject.

Inside of Me

.

This empty space I don't speak much about

Has been eating me all up,

The secrets I keep and the lies I tell

Has only built this beast inside of me

That has controlled me my whole life,

To which I have over looked and avoided.

Speechless about it,

But will talk continuously about anything that doesn't bother me,

But my empty space is empty with a deep voice that hollers at me.

All the time I hear you will remember me,

Its hard for me to think straight when my emptiness is riding me.

Even when I'm alone,

The loudness gets louder and louder,

And I cry because the words relate so much from the past.

All I can remember is the hurt from back then,

And it plays over and over and over again.

Emptiness will not let me forget,

Inside me I have a hole deeper than Lake Michigan,

And when there are those who try to fill it,

They sink without a trace to even be saved.

That beast is eating me alive and those who were in my life.

Memories they play, good and bad, each day.

And each day I fall in debt of depression,

Helpless and eventually breathless,

As my breast decreases from fearful inhalation,

My emptiness rumble and roars as an alarm to awake me,

This is so serious my emptiness really hates me.

It has to, for me to hold these memories that play faithfully,

I just want this nightmare away from me.

Because this hole, this emptiness, happiness has retired from me,

Never will it appear again, not in or before me.

The brighter side I will never see,

This beast is this hole with a mouth wide open,

Swallowing all hope I once had.

Even as I attempt this emptiness is much deeper than it began,

I just this forever deep hole to end.

I need the strength to fill this hole,

Forget this hurtful beast,

Let go of the thoughts that hinders me.

Ever been hurt so bad that you were killed with memories?

Dream Killer

.

Life is but a dream

And it is life when living,

Where's the discussion

For struggling, fumbling,

Frustration and depression?

The nightmare of not making it,

Constantly praying,

But not seeing the promises

Of the biblical testaments.

Not having,

Mindful of the things I'm lacking.

I mostly speak of the world and their thoughts,

But I'm in deepness to speak my experience.

There are levels to this,

No complaints!

Its just expression on how busy the devil has been.

Starting from head, reading daily breads,

But still short of the fulfillment

And understanding from things read,

Even contemplated on meds

Easy route to just lay my soul to rest.

Don't judge, it was a thought,

Not saying I did.

If I did, I'd be on the other side

Like I should've lived,

Or given myself more time to sit and think things clearly.

The time God has already given me.

What I ponder on when angry?

If I had the time to write the book,

Then many would realize we are not alone in misery.

We are all climbing the walls of mountains,

Some are further ahead.

That is when confusion speaks,

Personal evaluation,

Like could it really be me?

Am I the hindrance of my own dream?

Topics I mentally seek

While climbing in other words, striving.

I am my own enemy,

Hurting myself constantly harming me,

Belittle, doubting destroying myself?

I am the victim of spiritually, mentally, physically

Killing myself...

Career VS Love

.

My whole life my goal was to,

Have true love and establish a career life.

No matter what order it came,

As long as they are both present,

I'm pretty much alright…

Stayed in school played with puppy love,

Balancing them both,

With no clear direction

And didn't know if I should stop or go.

But what I did know

That my goals would be reached,

And I'm guaranteed to have both.

Passionate and ambition,

And while having my ambition,

I am sure to keep my passion

About my choices in life,

And if love would be just right.

But I wouldn't know until I experience life.

Learning as I aged,

That you have to stay focus,

Create a plan, widen your choices,

And let it be heard, your voice!

But I don't remember,

If the topic was about my love life or my career choice.

My focus was to be somebody,

Work my way to the top.

Adapt to the environment, but not adjust,

But to strive and make better.

Also, give my all,

The blood-sweat-tears,

Keeping my eyes on the prize.

Be bold in my every move,

But being careful of what decision I choose.

But I think the topic was about me working,

Towards my career or about love.

Now I have learned the right things

And feeling that all statements apply to both,

So I decided to mix and engage,

As an understudy, but really didn't think much of it.

While in the midst,

It hit me,

No one expounded… clearly about time.

There is no way in climbing both ladders,

Being successful in two things,

That really matter

Can be accomplished at the same time.

Something will lack,

Will not get done.

These motives are hectic,

And the time I put in makes none of this fun.

As I realize,

Either my love life was up,

While my career was down.

Or my career was kicking,

And my love life was just there on the ground.

So what's a passionate working/loving woman to do?

Before I could let go of the things that made me grow

And pull through.

Instead, I formed a task to multi-task,

Just continue to be who I am,

Give my all and not to expect

Something great in return.

Because as I work,

Greatness will come.

So I work, work hard,

Continuously, to have what I hoped for.

And one day they would meet me both,

As I stand in the middle.

As I learned as pleased as I would be,

That my hard work will pay off,

And in due time,

My career and love life will become of me equally.

And I will have what I've wanted all alone,

The two things I feel would complete me.

Now the topic is clear to me,

For the conversation I had with my two opponents,

Career on the left,

And love on the right of me.

The point of it all is that it starts as it being,

What's best for me.

My Hard Times

.

You may look at me and say I'm crazy,

But I'm rightfully requesting my hard times.

That mega-second of pressure,

That up beat heart rate.

Yea, its taking me fast,

But nobody stops me,

That's only going on inside of me.

See I don't mind my hard times,

It becomes an additional page to a new chapter,

And every chapter adds to my journey,

Of a long path to my thick book that seems to match my curves.

Now that's an image I can display,

See going through something

Means I'm learning something.

And taking what I've learned,

And apply it to my actions.

Let me just say there is a new woman before you today.

My hard times are a part of me,

I've learned that my hard times could never discard me,

Or end my life by tossing me.

It could only build me,

do arts and craft, and create me,

and make a stronger bond with my God and me.

Like I ask before, where are my hard times?

Freedom of Speech

.

As a kid I pleaded to be older,

Make my own decisions and be a grown up.

To feel more freely,

Scissors cutting from parental boundaries,

And to have my own place.

No disrespect... just in case.

Only the fun part, live it up,

Grown... but a kid at heart.

Never hit me with the convenience mama gave me,

She did her job made it look real easy.

Paying bills, took care of me,

Made a way when that way looked unreal to me.

Being out of school and on my own,

The mental pain started,

Worrying and less sleep.

Even though they said take it to Jesus,

I knew that, but being human,

Stress developed as an organisms character.

Talk about the bottom; red rose sausages,

And hot links, cornbread and buttermilk,

But finance, still holding me hostage.

Hustle, hustle is all I could ever think of,

Should have stayed in school,

But then I'm like never mind.

I think its time to put the child up.

Face responsibilities, making ends meet,

But all I see is expensive parties,

Popping bottles as I flip channels on tv.

I wasn't wishing it was me,

But I said if it was I would make stress ignore me.

Seriously, I look in a magazine

At different types of celebrities,

Questioning, did Sallie Mae call you today?

How full is your frig?

Did you eat what you wanted?

Did you give a dollar to the less fortunate today?

(without advertising or telling the public)

I could only turn the page, look at my phone and press ignore…

But only during,

I remind myself no economy can have a hold on me.

Most places only take place, mentally.

If they say there is no more racism,

Remind them of their fantasy.

It gets even worse,

It shows from skin to skin,

Our very own, who only has their own,

Makes it their own because they are on.

And can only speak of looking down,

To see many of us reaching up.

Their response is turkey and ham, COLD CUT!

Just think if Harriet Tubman did it?

Left the rest behind!

If we unite,

I mean really pull tight, our society can be higher.

Reaping the greatness of which God speaks.

Or even Martin Luther King who said,

"Sit at a table of brotherhood"

Instead of reflects of your hood or whoever hood.

Our potential is greater,

We the women forgetting our worth,

But we never lost our value.

Never let no one tell you

That you are not and never will be,

Those are the same ones who want to be... YOU!

This should not be the gift of our future.

Surely, this is not our present that was given.

The only hope for, is to hope for a better chance and new beginnings.

I, the Lady!

· · · · · · · · · · · · · ·

You probably can't see,

But there are a lot of cuts on my body.

Not physically, but the emotional tear

That has ripped and pierced me.

The hatred and jealousy,

Some of it has been painful to me.

But I was told when I was young,

That things would become critical for the life of a lady.

It amazes me...

That I could walk in a room full of strangers

And name later thrown out,

Harshly in the streets.

I'm this, I'm that,

When no one even knows me.

Oh but there is something I'm doing right.

To stir up this down home cooked ignorance,

On a job, in a church, or any usual place I would be.

Is where they would put my name in dirt expecting me to be,

That homewrecker, adulterer, a self-made hoe.

And why you ask?

Because I carry that confidence,

Speak with common sense.

Dot my I's, cross my T's, which spell "IT."

And if IT is what IT is,

Then I have IT.

It is all of what you say,

Just know you could have it too,

If you weren't so concerned about this.

Must be the best you have ever seen,

But all I'm saying is I'm just me.

I have my flaws, in which you make look perfect.

Trust me, I appreciate the compliment

That were spoken from your eyes,

And between your teeth.

I seen you get up, when I stepped in,

You couldn't even stay in your seat.

I thought I was getting a round of applause,

But when you walked away,

Butt and your shoes start clapping for me.

So I appreciate the speech,

Your body language wrote for me…

Am I?

.

Am I the new generation,

The woman of today's society?

I question, because I do feel like the alias,

From mothers womb,

Even when I stepped outside.

My feelings are crushed that I am only to appear

As a trick, hoe or a slut that,

Pleases with insecurity.

Clothing a little skimpy and persuade others to think,

I am cute, attractive and pretty.

And I ask to you, is that me?

Because in me I do not see.

I am not that along the way material,

Nor am I pumps, skin tight denim

Or other man made material.

I don't even like attention,

So I am who they hide.

I am not an updated woman of the stereo-type.

You will never hear my description on the radio or rap video,

Am I the new generation?

Do I fit in the category as an option of

"I will marry your type?"

Can my inner brain and beauty expose me?

I think they are more quite fitting,

And up to part than my clothes be.

Why even be surprised when you learn I am A-K-A?

Pretty girl 1-9-0-8, two birthdates of being beautifully made,

January 15th and June 17th 1988.

I am Sharice, classy, elegant, and real; each and everyday.

What other homo-sapien can attempt the challenge

Of a real unique woman?

Like an obese man on Thanksgiving, step to the plate.

I am not a woman of today's society,

But a woman that highly speaks for her character.

Too much, that this message is not meant to be ongoing,

Just a few words of notice that I among the few that remains.

Real woman, salute yourselves!

Created Generation

· · · · · · · · · · · · · ·

Don't look at me with those ungrateful eyes.

Saying we are not enough,

Widely to consume inconsiderate ways.

That's what older generations say,

But keep in mind, you were the ones building the program,

That we're selected to play.

And don't like our external, graphic design error.

You created this team,

But don't agree with most players.

You introduced us to the technology that we basically live for.

You did all the hard work,

While our biggest concern is what's in our wardrobe.

Mentally stuck in a war zone.

Ring the doorbell, guaranteed no ones home.

Only care for oneself, home alone 1, 2, and 3.

There is no need to lie, we are behind time,

And for you, you're in pain,

But we're the ones in misery.

No matter how you think we are suppose to think.

Look at what we have to idolize.

Million dollar dreams,

While the "go getting" is a nightmare.

There is no typo,

We were formed to be that type though.

Look at us, kill, steal, and destroy,

You say that is all we do.

It just seems to me the devil is fulfilling his duties.

But you can't place the word of God in our hands.

Just want to stretch your arm out and shoot us.

So US worrying about US, didn't start from US.

It was through YOU!

But we are the blame, pointing fingers when you're the shooter.

You can't fool us,

Go ahead and scratch your forehead,

We are not the ones clueless.

You are the ones who programmed us without the blueprint.

Wasn't warned about our capabilities,

I assume you didn't read the fine print.

My vision says you were desperate

To lift the weight off your shoulders,

And have it placed on us.

You lifted your weight, but brought more on us.

Is this what it all leads to?

This is coming partially from those

That didn't think they were slaves who,

Didn't believe Harriet Tubman when she said "I will leave you!"

And all that you have you learned is whatever they (masters) taught you.

Thinking that it will leave and seep in us too.

We learned our voices and started to speak truth.

Our generation was created,

But reshaped from what you did and what we do better.

Wake Up!

.

In reality I have simply realized,

It is time to no longer dream.

To not think about putting out,

Where to start,

And ponder on the financial reap.

The normal sit back and see,

Wake the hell up and do!

We are not in the 3rd grade

And being asked,

When you grow up, what will you be?

Or what is it you want to do?

Looking at the curves and height;

We have grown, but in mind

We're still in high school.

The dream, lets take the time and create action.

Those of you who do this,

Where is the strategy

To make it a reality?

To say "keep it real"

Prove the realism of surviving from integrity.

The bulb above brain that ignites

The blue print, game plan.

And with anyone who starts from the ground,

Has to stumble before growth.

I just want my people with goals

To wake up, get up and GO!

LIVE

· · · · · · · · · · · · ·

Life, what will it be?

Me? Well, my plan is to live you.

See, I have stood in the shadow of fear for many years,

That fear leads me to unfaithfulness in oneself.

That is when I had the thoughts of,

Who am I?

Am I who I should be?

Falling in this insecurity that has covered my identity,

And I have been unknown lately.

Staying in that shadow of darkness,

Scared of all the evil and not seeing myself

Or the warrior I have become.

Yes I can talk it,

But all along I'm missing something.

Restless, stirred in my own message

That later became untold stories and my lessons.

Life, what will it be?

Me? Well, my plan is to live you.

Pull away from others and what they do.

I, created to speak,

Not only am I a vessel but a tool too.

That cannot be hidden,

Take that away then me and my voice is missing.

Until then I live on a mission.

Not to disturb the next soul,

But I just want ears to listen.

The only time there is silence is when we should be

Slow to talk, quick to listen.

The question is when?

That's when we have to pay attention.

Vital information, major rule.

But this is to only be applied

With who value the worth of living.

I mean actually living.

Not standing behind closed doors and can't see your image.

The visual of the alive,

We no longer see the 6 feet and caffeine

But though the dead is walking,

We must do better for us.

Life, what will it be?

Me? Well, my plan is to live you.

Because you have shown me in reality… I must live for me.

Life's Puzzle Pieces
· · · · · · · · · · · · · · ·

The tears in my eyes are not enough to reveal my hurt.

A young lady whose life are just multiple puzzle pieces,

Being put together by a blind man.

Laid all over on a wooden table,

Some on the floor being ignored

Because they cannot be seen.

I am not seen because those pieces are me.

Feeling the shape;

So the assumption is it should go here,

That should go in this corner, it fits perfectly here.

But the placement is incorrect,

So now this piece (me)

Is bent, rigged, folded.

Not as crisp as I was in the beginning.

This picture (my life) is incomplete.

How dark is this picture?

Is it colorful, quite detailed, is it vivid clear?

What is the description on the box?

Does it tell you what it looks like?

Blind man is not stopping,

Determined to get this picture (my life) together.

Exciting guessing, but knowing

This is how it is suppose to be.

The good life, being a great wife,

Child, picket fence, big house,

Or cooperate career, top of the line,

Changing the world making a difference.

Still putting the pieces together one by one,

Constant fumble circling the edges

With index finger.

I don't know where this is going,

I'm just going with the motion.

Oh I'm moving but slowly coming alone.

Eventually, this picture will be complete.

Blind man, take your time!

There is no rush,

I'm fidgeting, nervous, not knowing what I (this picture),

Will become or will be.

Afraid to see the end and my accomplishments

Will be incomplete.

If I start a movement and get it all wrong,

When I tried to get it right.

If I am this runner and I stumble and lose this race.

Hold up blind man!

Do not place my last piece in that puzzle!

I am not ready!

I do not want to be this disappointment...

Blind man pauses, because he heard my cry and slowly replied;

"In everything you ask God for

Your purpose, your faith, your gift

And your strength has been made.

Me? I am just a man who cannot see,

But putting your puzzle together

Has been fulfilling to me.

Because I feel your struggle,

I felt how you overcame,

I laid my hand on your heart and felt your every ache,

But you mastered,

You succeeded in exceeding.

And as I lay this last piece, I can't see it,

But I feel the master in you,

This picture shows that God is in you.

Life is complete and your path is directed.

You just ask God to point you out in his direction,

And once you open your eyes at this picture

You will see God created a marvelous, Master Piece.

With your life and words,

What eyes can't see every soul will feel.

Change

· · · · · · · · · · · · · ·

I think that its crazy when they say,

The world is changing for the better.

Hateful crimes done on a daily,

Families burying babies,

And toddlers who never mature to what life could be.

The extension of living is not as long as what it use to be.

Stress, for every black man who hustles to maintain,

Determined to do different in order to make change,

With his kids and even exchange neighbors.

Gunshots sound more like doorbells,

And when body lands we view as occupants at theaters.

Depressed, not being able to provide,

The pain, the heart

And the only he sees it is with gunshot between eyes.

To no longer feel the unfairness and not having the opportunity,

As he repeatingly says, "Livng life is killing me,

And the only who can see it are those who can sentence me!"

There are no helping hands,

And the Christians are non-participants.

We wouldn't know that the man that is

stranded is sitting right next to us,

we yelling getting money and we all about getting money,

but forever poor.

Notice the struggle for a buck, but in line for Jordans.

When he only re-release in different colors.

Now our ancestors we slaves for white men,

But now we are being slaves for a brother.

And we don't love each other,

Because if I don't have and you have,

Then you say I have nothing or that I am nothing.

Being as the people hundreds of years ago who bypassed this blind man.

Who seemed as if he had no value.

The same man who pleaded and cried for help,

The same man Jesus reached his hand out to.

So, you mean to tell me, we can't help each other,

The same thing God brought his son to do?

A miracle I asked to be performed on me,

You, you, all of you.

We were born with individuality,

But lets create a formality that will show our living is not in vain.

So for that brother that is struggling on these cold, cold streets,

Change that!

For that mother that is being a mother alone, Change that!

For that child who cannot read, cannot understand,

There for he lacks confidence, Change that!

Keeping our own out of jail,

To not be against, but be that help, Change that!

To be for our people and with our people,

Let's be the generation that changes for the better,

And prevent the world from changing us!

I think that it's crazy when they say the world is changing for the better!

But we must change the world before there is no more us,

And all we will ever become, or ever will be is BLACK HISTORY!

About the Author

.

Who am I? I am a poet born and raised in Canton, MS. A young Gemini, who has searched for many years why am I here? What is my purpose? These questions came to me more than often once I graduated from Canton High and went to MVSU. I realized who wants to be lost as a young adult? I begin praying, searching, wondering why God has me here. Growing up in church you learn early that everyone has a purpose, but it is up to you to listen to God and fulfill those duties. I actually started writing poetry in middle school, but no one knew, until I graduated college. My first time before an audience was at my home church, Mt. Able M.B. church, and I kept going. From then on I wanted to do more, I wanted to express myself continuously, and this is what motivated me to write this book. I want to spread to the world who I am, what my words consist of, and please God, because I'm thankful for this gift and I will use this gift to uplift us all and read how I think and feel.